A GUIDE TO
AMERICAN INDIAN FOLK ART
OF THE SOUTHWEST

Western National Parks Association
Tucson, Arizona

Published by Western National Parks Association

The net proceeds from WNPA publications support education and research programs in the national parks. To learn more, visit www.wnpa.org.

Written by Susan Lamb
Edited by Abby Mogollón
Designed by Dawn DeVries Sokol
Photography by George H.H. Huey
Printing by KHL Printing, Singapore

Cover art by Justin Ben
Title page art by Delbert Buck

Special thanks to the artisans who contributed work and spoke of their experience. Also thanks to Laurie Amado of Kaibab Courtyard Shops, Mark Bahti of Bahti Indian Arts, Jack and Jason Beasley of Beasley Trading Company, Joe Bianculli of Western National Parks Association, Terry DeWald, Anthony de la Garza of Painted Desert Trading Company, Jim Griffith, Jed Foutz and Kent Morrow of Shiprock Trading Company, Marianne Kapoun of The Rainbow Man, Kent McManis and Bob Jeffreys of Grey Dog Trading Company, Jan Musial, Robert Seymour and Marshall Kidder of Turquoise Skies Trading Post, Barry and Georgiana Kennedy Simpson of Twin Rocks Trading Post, and Tony Weber of Palms Trading Company.

CONTENTS

INTRODUCTION

FOLK ART can best be described as objects that illustrate everyday life made by people who have no classical art training. Folk art is often spontaneous—the product of free time, some readily available materials, and a sense of humor. It tends to be whimsical and engaging, wry at times but more often refreshing. Its shapes are simple, its colors primary, its subjects familiar. While there is an element of the sacred in all creative work, Indian folk art is intended for sale not for ceremonies. (Sacred objects are not referred to as "art" in American Indian cultures.)

Folk art is a personal as well as a cultural statement, a mingling of tradition and modernity that is reality for indigenous people today. It usually reflects what an artisan actually sees: a real horse or truck or grandfather instead of stylized, classical beings or motifs. Seldom produced in the peace and quiet of a studio, folk art more often comes from a little house where sand blows in an open door, children and dogs are always playing underfoot, and a host of other chores need to be taken care of throughout the day. It bridges the gap between cultures while enabling people to earn a living and maintain ties to their families and way of life.

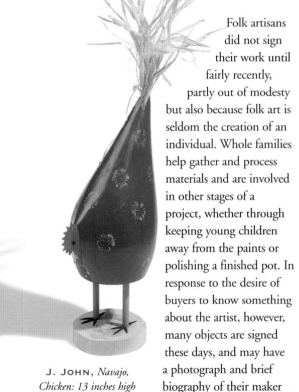

J. JOHN, *Navajo,*
Chicken: 13 inches high

Folk artisans did not sign their work until fairly recently, partly out of modesty but also because folk art is seldom the creation of an individual. Whole families help gather and process materials and are involved in other stages of a project, whether through keeping young children away from the paints or polishing a finished pot. In response to the desire of buyers to know something about the artist, however, many objects are signed these days, and may have a photograph and brief biography of their maker attached.

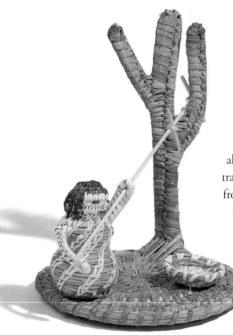

HISTORY

THE PEOPLE OF THE SOUTHWEST have always made things for trade to other cultures, from the imported pottery found in ancient Puebloan sites to the baskets Paiutes made for use in the ceremonies of their Navajo neighbors. From their very first contacts, early European explorers and indigenous people exchanged handmade objects that offered insights into each other's lives and values. After the Civil War, trading posts in New Mexico and Arizona made some Indian baskets, pottery, and rugs available to buyers around the country, and the interest in southwestern Indian arts and crafts boomed in the 1880s with the establishment of transcontinental train service.

DELLA CRUZ,
Tohono O'odham,
Fruit gatherer: 8¼ inches high

The ensuing rush of tourists to the Southwest in the early twentieth century coincided with the Arts and Crafts movement and its taste for the handcrafted objects of preindustrial cultures.

This market quickly influenced what American Indian artisans made and how they made it. Souvenirs had to be inexpensive and reasonably easy to transport. They also had to "look Indian." Traders gave weavers rug patterns that would appeal to buyers in the East. When tourists leaning out of train windows with dollars in their hands preferred pottery with certain designs, potters made more with those.

Interest in Indian arts and crafts ebbed with the Depression and the Second World War but returned when Americans started driving west on family vacations. Beginning in the late 1960s, a cultural renaissance led to increasingly exquisite work by Indian artists with an undercurrent of trade in less expensive folk arts and crafts.

Throughout the history of Indian folk art, different genres from carving to weaving to ceramics have enjoyed blooms of popularity from time to time. Sometimes the surge in interest is due to the creativity of a single, original artisan. At other times it occurs in response to a trend in mainstream culture.

COLLECTING FOLK ART

FOLK ART IS EVOCATIVE. It can bring back the scent of coal smoke in a Pueblo plaza, the baaing of sheep along a rural roadside, or the feeling of expansiveness in a wide-open southwestern landscape. It can be a reminder of a cheerful encounter or a sudden understanding. It can simply charm us.

As a result, folk art lends itself to impulse buying. Fortunately, investment-priced folk art is the exception rather than the rule. Folk art is usually an inexpensive way to enter the world of collecting. It makes learning about arts and cultures fun and helps to cultivate an eye for objects that will keep their appeal over time.

People collect for different reasons. Some might be attracted to things that make them laugh. Others may buy almost anything in the shape of a rabbit, for instance, or a bear. Children are great fans of folk art; dealers find little nose- and fingerprints on the outside of their shop windows when they open in the morning. Objects reveal what their collectors love—novelty, color, or humor—as well as a bit about their characters whether cheerful, generous, or dark.

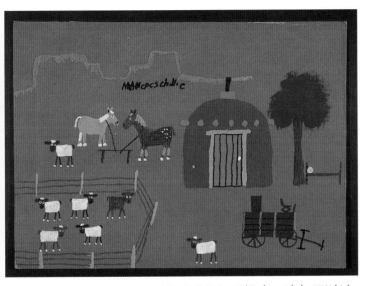

MAMIE DESCHILLIE, *Navajo, Painting: 24 inches wide by 17 ¼ high*

When asked why she makes her little basketry figures of people engaged in traditional tasks, Tohono O'odham artisan Della Cruz explains,

When I make one of them, I think about who they are and what they do. I think about the ladies using a long stick to get the saguaro fruit. I guess I feel that they need to be around. They let people know that our culture is alive.

DOLLS & FIGURINES

▨ MUD TOYS ▨

MUD TOYS ARE THE MOST elemental of folk arts. Created from sifted dirt and water, animal hair and hide, primary paints, and perhaps a bit of wood or stone, they were originally made by rural parents or their children before the days of store-bought toys. They depict the interests of childhood: A collection from 1923 includes a cradleboard and a baby buggy, a dog, a cat, a goat, a sheep, and a horse, as well as a grown-up man and woman.

Mud toys entered the commercial world in 1983, when Farmington dealer Jack Beasley asked Elsie Benally, a Navajo from the remote Sweetwater region of Arizona, to bring him something from her childhood. He had in mind a rug or perhaps a piece of jewelry, but she brought in a mud toy instead. Beasley found it charming and put it in a display case alongside items that were for sale. Customers kept asking to buy it, and so before long, Benally and others began making them to be sold.

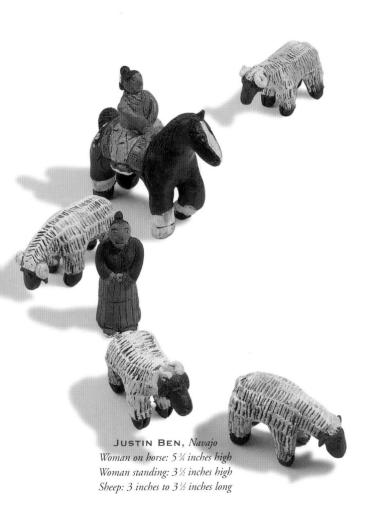

JUSTIN BEN, *Navajo*
Woman on horse: 5 ¾ inches high
Woman standing: 3 ½ inches high
Sheep: 3 inches to 3 ½ inches long

11

🗹 ANIMAL FIGURINES 🗹

SOUTHWESTERN CULTURES have made figurines of animals since ancient times. Whether of clay, plant fiber, or wood, they are often painted and may incorporate real fur, wood, cloth, bone, or horn. The animals are mostly familiar ones, such as domestic sheep, goats, and horses, or wild animals seen in rural areas such as porcupines, bears, frogs, turtles, roadrunners, and lizards. Occasionally, artisans depict exotic creatures such as elephants or giraffes.

Certain subjects and styles have special appeal to collectors, spawning innovations as well as imitations. One example is the brightly painted wooden chicken. Navajo artist Woody Herbert had sold a few wooden dogs over the years, but one day he made a simple chicken for a change. It sold immediately. Other artisans started making chickens too, some with innovations such as the *yeibichai* (ceremonial dancer) chicken.

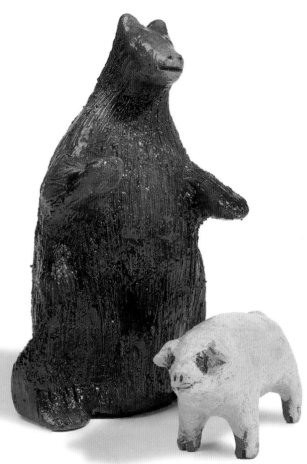

LOUISE GOODMAN,
Navajo, Bear: 8 inches high

LARRY BEN, *Navajo,*
Pig: 5 inches long

◪ SANDSTONE CARVINGS ◪

FOLK ARTISTS TEND to use whatever materials are available locally. As the market for folk art has grown, people living in remote areas have seized on the idea of sawing sandstone into rough shapes, refining them with rasps, and then painting them to fashion images from the world in which they live.

Finely textured and richly hued sandstone is exposed in the Southwest's Four Corners area. Due to the nature of the material, sandstone carvings tend to be bold and blocky. Artisans take advantage of any natural patterns in the stone but also usually paint them with the same primary colors used on more traditional American Indian crafts.

Sandstone has been a medium for southwestern artisans for millennia. The weathered faces of sandstone boulders are ideal for the incision of images called *petroglyphs*. The images carved by contemporary sandstone artists portray a different world than that of subsistence hunters and farmers and now they depict the features of rural life in the twenty-first century—cars and trucks, horses and sheep.

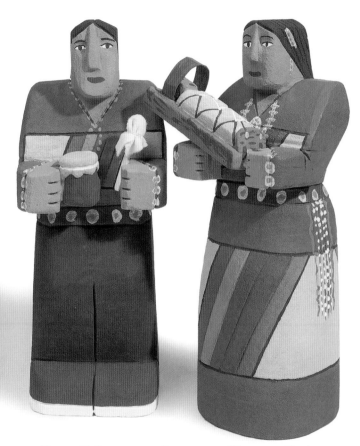

FLOYD T. BEGAY AND SERAPHINE WARREN, *Navajo,*
Man: 10 inches high
Woman: 10¼ inches high

⚄ ZUNI STONE CARVINGS ⚄

ZUNI PEOPLE HAVE LONG collected stones that look like parts of ancient creatures. They enhance these stones with carving or by attaching arrowheads or feathers to them to create *fetishes*. Fetishes were originally made for sacred purposes, but after collectors became interested in them, the market's influence led to the carving of stones for sale. Zuni carvers now use Dremel tools and other equipment to create masterpieces of meticulous workmanship from regional turquoise, bone, and agate in addition to semiprecious stones imported from all over the world.

The carvings available for sale today are not intended for sacred purposes and so those who make them are free to portray whatever they wish. With great creativity, carvers explore fresh subjects, often inspired by popular culture derived from movies and books. There is still a tendency to honor one's allies, however. Carvings of Smokey the Bear reflect the work of many Zuni people on seasonal fire crews.

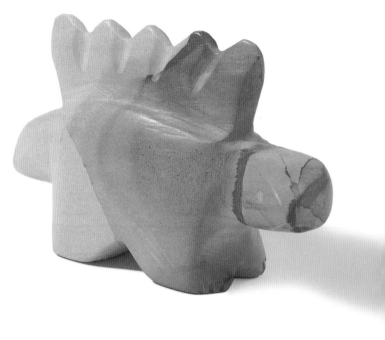

KENNY CHAVEZ, *Zuni,*
Dinosaur: 2½ inches long

⚡ RAIN GODS ⚡

IN THE 1880s, artisans of New Mexico's Tesuque Pueblo sold little ceramic figurines they called *munas,* or clowns, to the tourists who had begun to arrive by train. The outside world interpreted these munas as the "gods" of various concerns such as hunger, pain, and peace. During a ten-year drought that began in 1894, those known as "rain gods" became so popular that they were produced in bulk for gift shops, dealers, and inclusion in boxes of candy.

The mass-production of rain gods coincided with the commercialization of the American West and its native peoples. Many scholars and humanitarians considered the little effigies to be a sign of a decline in dignity and self-reliance among indigenous cultures in general. But rain gods spoke to the tourists, creating a connection between them and Pueblo people. They also provided much-needed income in Tesuque.

Rain gods are seated figures holding pots on their laps, with outstretched legs and upturned faces with slit eyes. Twenty-first century artisans find many ways to individualize them in shape and color.

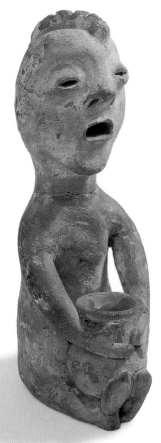

UNKNOWN, *circa 1890,*
Rain god: 8 inches high

◪ COCHITI FIGURINES ◪

SEVERAL PUEBLOS have made ceramic figurines of people and animals for many centuries. Potters from Cochiti, a pueblo on the Río Grande about forty miles south of Santa Fe, are particularly well known for a type they popularized in the early 1900s: caricatures of all sorts of animals and people, including spoofs of tourists, cowboys, and priests. Typically, these figurines are white with brown or black paint. Cochiti artisans also make *rivermen,* mythical ogres who live in the river and kidnap children, demanding bread as ransom. Figurines from Cochiti and other pueblos are sometimes fashioned into useful articles, such as frog-shaped business card holders. They are also made in sets as *nacimientos* (Christmas nativity scenes), *matachines* (dancers in a ceremony blended from Hispanic and American Indian elements), and objects related to other events in village life.

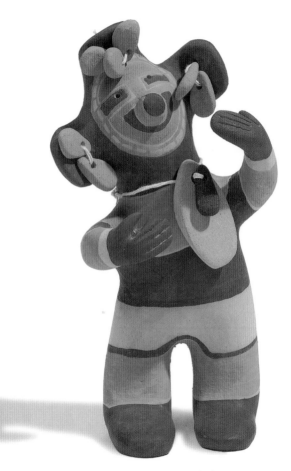

INEZ ORTIZ, *Cochiti,*
Figurine: 7¾ inches high

◪ STORYTELLERS ◪

STORYTELLERS ARE A GENRE of folk art that can be traced to an originating artisan. In the early 1960s, Helen Cordero made a nostalgic figurine of her grandfather telling stories to the children clambering over his arms and lap. This original storyteller was an adaptation of Cochiti's "singing mothers," seated ceramic women with a child or two on their laps, which were commonly made in the 1950s.

With its universal message of an elder sharing wisdom and affection with later generations, the storyteller became a great success. Artisans from virtually all southwestern Indian groups now make them. They also depict nearly every imaginable subject, from tortoises to goats, angels to French poodles. Some are very intricate, with dozens of children or baby animals on an elder's lap. The elder often appears to be conguring a tale from the depths of memory and imagination. In size they range from miniatures to large garden ornaments.

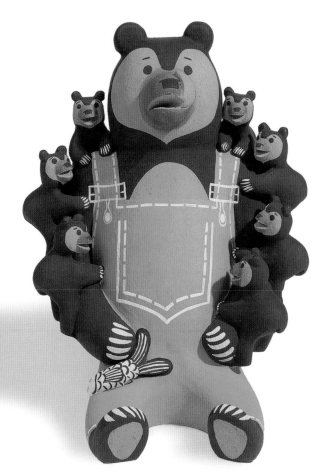

DOROTHY HERRERA, *Cochiti,*
Bears: 8 inches high

◪ CLOTH DOLLS ◪

NAVAJO CLOTH DOLLS have remained popular as souvenirs since the nineteenth century, partly because visitors to the Southwest still encounter Navajo people—especially women—in traditional clothing.

This "traditional" clothing dates from the era of the Long Walk, when Navajo people were imprisoned at Fort Sumner in New Mexico from 1863 to 1868. Navajo women adopted tiered skirts at this time, through either copying the dresses of Army wives or wearing donated clothing, including petticoats designed for hoops to hold out the long skirts then in fashion.

After their release from Fort Sumner, Navajo artisans began making silver jewelry. They put silver buttons and collar tabs on their shirts, wore heavy bracelets and necklaces, and attached silver disks called *conchas* (shells) to their belts. A doll's jewelry may be a miniature of the real thing but more often is made of foil, sequins, beads, or rickrack, or is drawn with metallic gel pens. Moccasins may be suede or fabric or indicated by paint.

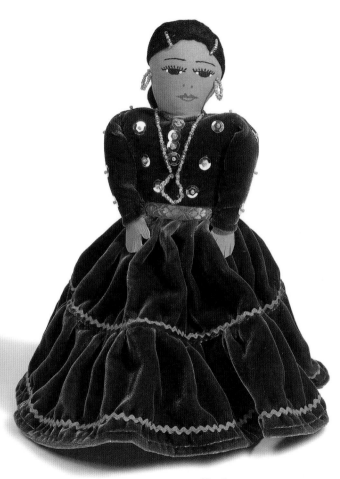

PEARL JOE, *Navajo,*
Doll: 10½ inches high

◪ BEADED DOLLS ◪

A TRADER NAMED C. G. Wallace is credited with initiating the making of beaded dolls at Zuni around 1918. He promoted them as an alternative to pottery, since Zuni Pueblo is comparatively remote and pottery is awkward and expensive to ship.

At first, artisans made just two kinds of beaded objects: cowheads and Comanches. Artisans used a sheep's vertebra as a framework, wrapped strings of beads around it to depict a cow's face, and left the pointed extensions sticking out to represent cow horns. Comanche dolls depicting the men and women of Plains tribes were usually beaded around rabbit's feet and sold as good luck charms. Zuni and other Indian artisans have more recently experimented with subjects ranging from the ceremonial dancers of various tribes to storytellers and trees full of birds. They also make sets of figures representing village or nativity scenes.

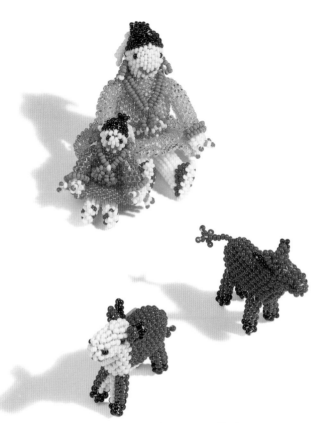

CLAUDIA CELLICON, *Zuni,*
Woman and child: 2 inches high

TODD PONCHO, *Zuni,*
Cows: 1¾ inches high

◪ PEOPLE OF WOOD ◪

GENERATIONS OF SOUTHWESTERN artisans have carved humanlike figures from wood for ceremonies. Among the Navajo, figures from wood were not made for amusement but rather as "illness dolls" for the sacred purpose of transferring pain or sickness from suffering patients. During the twentieth century, carvers adapted this ancient medium to express everyday aspects of their world. In 1961 and 1962, a Navajo healer named Charlie Willeto carved hundreds of wooden figures of people and animals not for ceremonies, but rather in response to an innate urge for expression.

Once the barrier to carving people from wood was overcome, other Navajos began to carve and paint wooden figures as well. Today, artisans of note from many tribes carve people and animals in several distinct styles, often portraying their subjects doing non-sacred things.

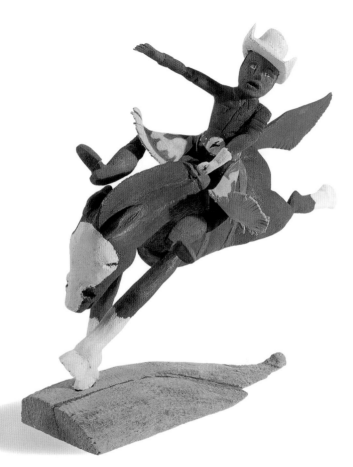

LEON HASTINGS, *Apache,*
Cowboy: 10½ inches high

CERAMICS

O'ODHAM
⧄ ROUND DANCE BOWLS ⧄

ROUND DANCE BOWLS represent people holding hands
in a traditional Tohono O'odham round dance. This
ceremonial dance is performed to celebrate the harvest of
saguaro fruit in the O'odham's Sonoran Desert homeland.
Because everyone who is present at the dance is invited
to join in the circle, the circle dance is a symbol of
friendliness and conviviality. As a signature expression
of O'odham culture, round dances are also performed at
special events around the Southwest. The dancers are
often children, who in a gesture of cheery fellowship,
break up the dance briefly to pull onlookers into the
circle amid much laughter.

Potters from the Angea family first made round dance
bowls in the mid-1970s. These bowls have higher sides
than usual, with parts of the rims cut out to leave circles
of human figures like gingerbread men, holding hands
around the top.

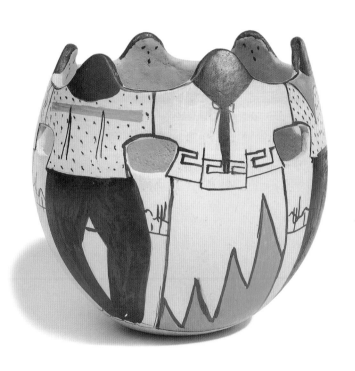

ANGEA FAMILY, *Tohono O'odham,*
Bowl: 6 ½ inches high, 21 inches circumference

PUEBLO
◪ FRIENDSHIP BOWLS ◪

PUEBLO "FRIENDSHIP BOWLS" originated with Corrine García of Ácoma Pueblo. She was inspired to make them when she saw her sons gather to play with other children around the rainwater cisterns of her ancestral village. She molds figures of children and attaches them around the lip of a bowl to look as if they are hanging over the edge, investigating the contents. Sometimes, there are dogs among the children or a frog in the bottom of the bowl, just as if it were a real cistern.

Other Pueblo potters have introduced elements from their own imaginations into the genre. Some make animal friendship bowls, with pigs or Dalmatians or other whimsical creatures. Whatever their subjects, these bowls evoke the timeless qualities of curiosity, friendship, and delight.

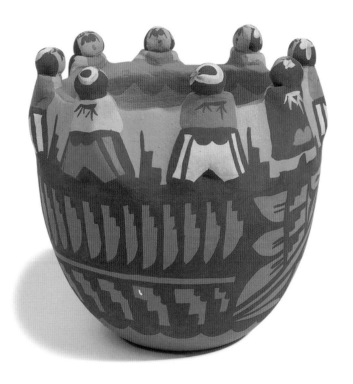

CAROLINE SANDO, *Jemez,*
Bowl: 4⁹⁄₁₆ inches high,
15½ inches circumference

⚏ PICTORIAL CERAMICS ⚏

A CERAMIC SURFACE is a wonderful canvas for a folk artist. The medium lends itself to spontaneity and gives free rein to the imagination. Whether painting the inside of a bowl, the outside of a jar, or the flat surface of a plaque, artists explore boundless subjects and styles.

Painting pictorial ceramics is not unlike painting frescos on wet plaster, in that the painter must work swiftly and with confidence. Because the porous surface of the clay absorbs paint instantly and indelibly, images tend to be quick sketches rather than studied or precise designs.

Some communities, such as Santo Domingo, once considered pictorial ceramics to be a violation of religious principles. Today, artisans of all backgrounds paint pictures on pottery. Whether showing a scene from everyday life or a dinosaur inspired by a children's book, pictorial ceramics illustrate what is on the minds of Native artisans.

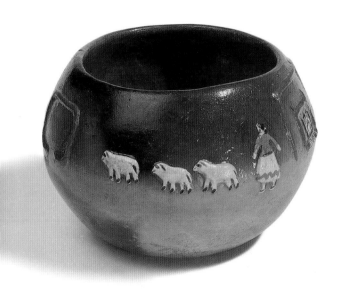

BETTY MANYGOATS, *Navajo,*
Bowl: 4¾ inches high,
20½ inches circumference

◪ APPLIQUÉ POTTERY ◪

FOR CENTURIES, southwestern potters have pinched and carved the clay of their vessels to decorate them without paint. These designs may be functional—as in "corrugated" cookware, which has a rough surface that distributes heat and makes the pot easier to handle—or ornamental, or both.

As potters began to make objects for sale, they were liberated from most practical and stylistic considerations because their wares were no longer intended for use in ceremonies or for cooking or serving food. Beginning with such simple, easily recognized shapes as snakes and lizards, corn and clouds, potters began to attach increasingly bold and elaborate effigies to bowls and jars. Potters now put all kinds of molded shapes on the outside and inside of their pots, sometimes going so far as to decorate the inside of their bowls with village scenes or whole flocks of sheep.

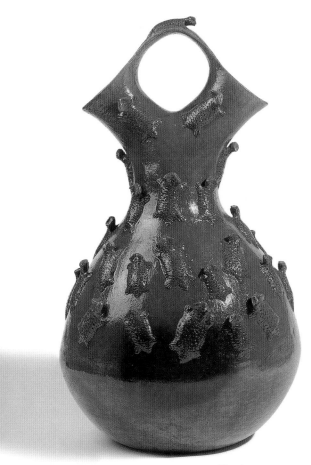

BETTY MANYGOATS, *Navajo,*
Wedding vase: 20½ inches high,
36 inches circumference

FABRIC & FIBER ARTS

◪ QUILTS ◪

SCHOOLTEACHERS AND MISSIONARIES introduced quilting to the people of the Southwest about a century ago.

Quilts have since been integrated into Hopi culture as the customary gift from relatives at the baby-naming ceremonies that are still held according to ancient tradition. Hopi quilters—like quilters everywhere—also get together to show each other their work, to tell stories, and to teach the next generation.

Hopi quilts are usually made with cloth left over from other sewing projects or cut from old clothes. Scraps are sewed in patterns and may also be appliquéd, embroidered, trimmed with yarn, or quilted with Hopi designs.

Other native groups continue to make quilts as well. Among Apaches and others, star quilts are often made to commemorate special events such as weddings or the return of a soldier from war.

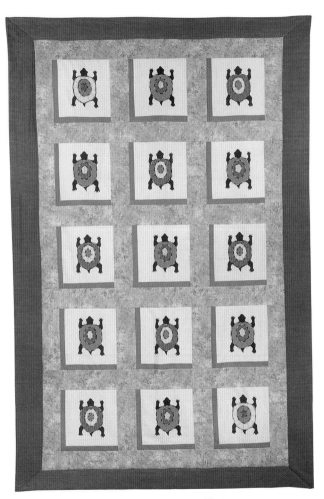

KAREN TOOTSIE, *Hopi,*
Quilt: 78 inches high, 53 inches wide

39

PICTORIAL RUGS

NAVAJO RUGS are a marvelous blend of American Indian and introduced talents, concepts, and materials. They are woven from the wool of sheep and goats, which were brought to the Southwest by Spanish colonists. Dyes to color the wool are made from local plants and minerals or are shipped in from distant factories. Rug designs may be based on ancient themes, such as the storm pattern with its weather symbols surrounding a *hogan* (a traditional Navajo home), or they may simply be pictures from the weaver's imagination.

In pictorial rugs, weavers have the freedom to convey their own impressions of a world that is a combination of the native and the introduced. In addition to landscapes, trees, birds, people, and hogans, pictorial rugs may illustrate trucks and trains, horses and cattle, Mickey Mouse, or a jet airplane. Rug weaving naturally lends itself to geometric images such as the American flag and the alphabet; small specialty rugs announcing "Home Sweet Home" or "Happy Easter" are popular for commercial sale or as gifts from a weaver to friends and family.

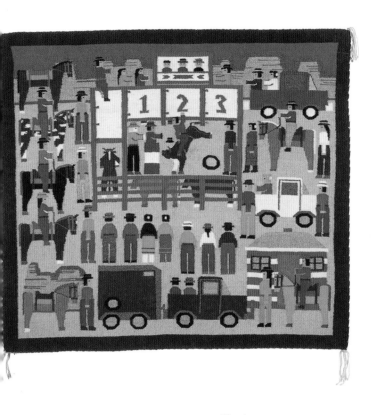

ELIZABETH YAZZI, *Navajo,*
Rug: 35¾ inches high,
39¼ inches wide

PICTORIAL BASKETS

EACH SOUTHWESTERN CULTURE has its own basket designs and styles. Some baskets were originally intended as carriers, others as containers, and still others as strictly ceremonial items. Many weavers now make their baskets to be sold and displayed.

In response to the taste of collectors, an increasing number of baskets have humans, animals, and plants in their designs. These are known as pictorial baskets.

Basketmaking is a yearlong endeavor in which every step is undertaken with great care. Even if the basket is not intended for a sacred use, making it is a creative act that requires reverence. Different fibers—beargrass, yucca, willow, sumac, and devil's claw—are gathered at different times of year to ensure that they will be both durable and pliable. These fibers must be cleaned and split and kept out of harm's way in spaces that are shared with many other tasks. Basketweaving requires concentration, dexterity, and a surprising amount of strength in addition to great reserves of patience.

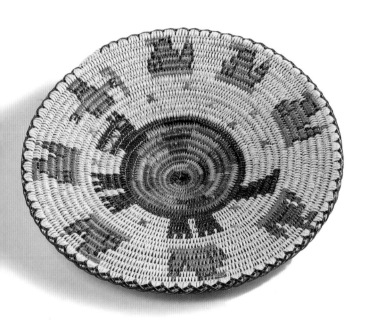

PEGGY BLACK, *Navajo,*
Basket: 14½ inches diameter

◪ BALING-WIRE BASKETS ◪

BALING-WIRE BASKETS are a reminder of the days before refrigerators were available to the Tohono O'odham of southern Arizona and northern Mexico. In those days, folks used baskets to store perishable food, either hanging them in ramadas (shade shelters) near the cooking area or suspending them down wells to keep their contents cool.

Folk artisans tend to use whatever materials are readily available. When hay bales were introduced, the O'odham began to use the stout wire that bound the bales to make strong baskets impervious to rodents' teeth or decay. Baling wire is very stiff and difficult to work with, but O'odham men use pliers to make loops so symmetrical that they look crocheted. No longer needed for food storage, baling-wire baskets are now made for collectors who value them according to their size and intricacy.

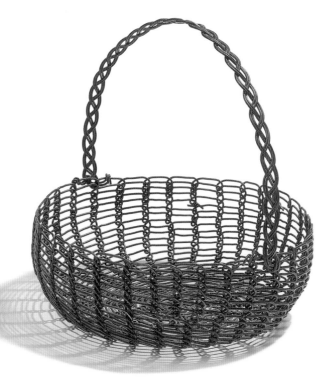

WAYNE PEDRO, *Tohono O'odham,*
Basket: 7½ inches high,
7½ inches diameter

◪ HORSEHAIR BASKETS ◪

O'ODHAM AND OTHER weavers also make baskets out
of horsehair. These baskets have great appeal to
collectors because of the precision with which distinctive
southwestern designs are woven using different-colored
strands of hair from horses' manes and tails. The baskets
are also very durable. Until the 1980s, horsehair baskets
were made as delicate miniatures. Now, some are a foot
or more across.

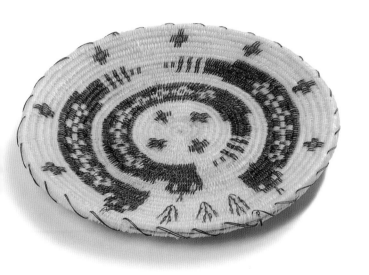

RUBY THOMAS, *Tohono O'odham,*
Basket: 3⅞ inches diameter

ALSO FROM
WESTERN NATIONAL PARKS ASSOCIATION

A GUIDE TO NAVAJO RUGS
By Susan Lamb
ISBN 1-877856-26-6

A GUIDE TO PUEBLO POTTERY
By Susan Lamb
ISBN 1-877856-62-2

A GUIDE TO ZUNI FETISHES
AND CARVINGS
By Susan Lamb
ISBN 1-58369-028-X

See your bookseller or visit our online bookstore at www.wnpa.org